I Hope This Finds You Well

Also by Kate Baer

What Kind of Woman

I Hope This Finds You Well

Poems

Kate Baer

HARPER PERENNIAL

NEW YORK ● LONDON ● TORONTO ● SYDNEY ● NEW DELHI ● AUCKLAND

HARPER ● PERENNIAL

Portions of the text were previously published in another format on the author's social media.

I HOPE THIS FINDS YOU WELL. Copyright © 2021 by Kate Baer. All rights reserved. Printed in the United States of America. No part of this book may be used or reproduced in any manner whatsoever without written permission except in the case of brief quotations embodied in critical articles and reviews. For information, address HarperCollins Publishers, 195 Broadway, New York, NY 10007.

HarperCollins books may be purchased for educational, business, or sales promotional use. For information, please email the Special Markets Department at SPsales@harpercollins.com.

FIRST EDITION

Designed by Jen Overstreet

Library of Congress Cataloging-in-Publication Data has been applied for.

ISBN 978-0-06-313799-8
ISBN 978-0-06-321961-8 (Indigo exclusive edition)

21 22 23 24 25 LSC 10 9 8 7 6 5 4 3 2 1

For my daughter

How

fragile it is, the world—I almost wrote

the word but caught myself. Either one

could be erased.

—Maggie Smith, "Written Deer," from *Goldenrod*

I Hope This Finds You Well

Author's Note

Around thirteen years ago I was sitting slouched over at my less-than-thrilling office job and decided to start a blog. It was the height of the blogging era, early 2000s, and I was twenty-three, aimless, and bored. I named it *Acquired Taste*, which is only slightly less horrifying than my first AOL instant messenger screen name (summerdreams19), and there I wrote short stories about wayward girls coupled with flimsy essays on feminism. As you do.

At its peak, I had about twenty-five dedicated readers, but there were also the times my site would randomly show up in someone's search results and thus began my first encounters with Strangers on the Internet. The first time I received a negative comment, I was at work eating lunch at my desk. It appeared under a story I'd written about a girl who realizes her friend has just died. The comment was from a faceless avatar named Brian and his message was simple: SHOW YOUR TITS OR GET OFF THE INTERNET.

It was upsetting, but also, really Brian? This is my turf! I hit delete. Over the next thirteen years of writing online, these sorts of comments and messages slowly increased while my reaction remained the same. What? No. Block. Delete. It wasn't until last year, when my first book was coming out and my inbox was flooded, that I started to examine some of these messages a little more closely.

One day I was reading one from a woman who did not agree with my feelings on police accountability when her words stuck out to me in a new form. On a whim, I took a screenshot of her message, blotted out some lines with the pen tool, and hit post.

The response to that poem juxtaposed with the original message was unexpected. Apparently, there are a lot of people at odds with Strangers on the Internet. Even more who are at odds with people they actually know.

It wasn't long after that first piece that I began to see poems everywhere. On billboards, in junk mail flyers, on the kids' vocabulary worksheets. And, of course, on the screen in front of me.

Over the past year, I have collected some of the best and worst exchanges from my corner of the internet and transformed them into erasure poems. It's not something I ever intended to do, sitting here poring over messages I would have otherwise deleted, though it begs the question—what art isn't a little accidental?

Some have asked if this experience has been the ultimate revenge. I will admit that at times this was a cathartic exercise, purging one canon in exchange for another. Other times, though, it was abundantly sad.

I have no doubt much will be written someday about our consumption of social media—what it gave to us and what it took away. For now, all I have is my own experience. And what I hope is a bit of light between the lines.

• • •

The messages, comment threads, spam, and remarks you see in this book are real for better or worse. I did not fabricate them, nor did I incite them by specifically asking for feedback on any post, essay, or book.

The subject titles, however, are all mine.

Names that are blocked out have been redacted for privacy and safety purposes. All positive messages have been shared with full permission by the author.

Finally, it is worth mentioning that I am not the first or last woman to receive unkind messages online. As a cisgendered white woman—I am merely the tip of an iceberg that launches straight down into a deep and ugly sea. My hope is that by sharing these pieces we continue to hold on to the truths that sustain us, and when we do encounter the inevitable noise—we tune our ears to hear the song.

e this finds you well. As you well know, life with two ch... ithout fear. Growing older may be inevitable, but that doesn't mean we h

is magical and chaotic. I don't say this to discourage yo... back and let it happen. I find your work well written, but the subject mat

o help. I want to be the success story of a life lived after pa... cessarily what I want to read about. It's just another morning in a thous...

without fear. Growing older may be inevitable, but th... ngs. Maybe I'm just not holding myself so rigidly. It's never been easier to t...

n't mean we have to sit back and let it happen. I find yo... of. Thank you so much for sharing these words with the world. I'd love to t...

well written, but the subject matter not necessarily wha... st an hour on the interview, so let me know what works best for you. You

to read about. It's just another morning in a thousa... to my day, to my life as a mother. Not everyone who disagrees with you

ings. Maybe I'm just not holding myself so rigidly. It's ne... erson. To love yourself is easier said than done. First, don't you think th...

easier to take control. Thank you so much for sharing the... outs just encourage trolls to message you? Solidarity to all caregivers, in...

ds with the world. I'd love to take at least an hour on t... shapes that caregiving takes, who are grappling with worry and stress,...

view, so let me know what works best for you. You... ve right now. I pray you find a way to live in the world but not of it. The o...

ds to my day, to my life as a mother. Not everyone who... that has saved me is support and kindness from strangers. Your greatest

es with you is a bad person. To love yourself is easier s... powerful resource here is literally just butting the hell out. Don't stop speak...

done. First, don't you think these blackouts just encoura... d out. It means more than you know. I will not judge, however the lord ab...

s to message you? Solidarity to all caregivers, in the m... Are you interested? No sacrifice. No naughty secrets. What is it abou...

es that caregiving takes, who are grappling with worry a... hy lifestyle that makes you so uncomfortable? I can say that I am the stron...

s, fear and love right now. I pray you find a way to live in... ver been. Even though you'll never see this, it's worth sharing. I hope this f...

d but not of it. The only thing that has saved me is supp... vell. As you well know, life with two children is magical and chaotic. I don't

kindness from strangers. Your greatest and most powe... o discourage you, but to help. I want to be the success story of a life lived a...

urce here is literally just butting the hell out. Don't s... and without fear. Growing older may be inevitable, but that doesn't mean

king up and out. It means more than you know. I will... to sit back and let it happen. I find your work well written, but the sub...

e, however the lord above will. Are you interested? No s... er not necessarily what I want to read about. It's just another morning

e. No naughty secrets. What is it about a healthy lifest... sand mornings. Maybe I'm just not holding myself so rigidly. It's never

makes you so uncomfortable? I can say that I am the str...

Re: Women in the White House

Good morning, Kate. I have seen your posts on hoping for female leadership in the next white house and I'm concerned that gender is now your only criteria. I'm not against women in leadership positions, however just ANY woman? We need to look for women who represent our American values. Women who love both God and this country. Women who respect the traditional family structure as a wife and mother while working to keep it safe. Women who will commit to pray for those suffering from poverty and illness instead of just talking about them. Women who respect limits and boundaries in their fields without always having to be the "know it all." The persecution women claim today is mostly fantasy. Men want what is best for women. More importantly God wants what's best for women which is why he will have a hand in this next election. Who better to lead us than God's own chosen one. I wish you the best as we move into the coming days.

I have seen

women

love this country

while

suffering from

its

persecution

Who better to lead us

into the coming days

Re: Why Americans Respect Conservative Women from Steve Bannon to the *New York Times*

There are some unintended consequences of the women's liberation movement. That, in fact, the women that would lead this country would be pro-family, they would have husbands, they would love their children. They wouldn't be a bunch of dykes that came from the Seven Sisters schools up in New England. That drives the left insane, and that's why they hate these women.

a consequence of
the women's liberation movement
 men that

 hate women

Re: When Chad Is a Dad

I think it's funny how much you hate men
and then go ahead and have this husband
like he doesn't apply.

Not buying your book, but if I was, I would
get it for my daughters to show them how
NOT to be.

Even though you'll never see this, it's worth
sharing not all women think like you or
believe men are inherently "against women."

They might even say they appreciate men
(can't fathom this? Maybe read a book
outside your "what kind of woman" bubble)

Sincerely, a man who believes his daughters
can be both independent and polite.

it's funny how men
 go ahead and have

 daughters

Even though

They
 can't fathom
 what

 daughters
can be

Re: That f****** b**** from Rep. Alexandria Ocasio-Cortez to the House of Representatives

I walked back out and there were reporters in the front of the Capitol and in front of reporters Representative Yoho called me, and I quote, "a f***ing b****." These were the words that Representative Yoho levied against a congresswoman. The congresswoman that not only represents New York's 14th Congressional District, but every congresswoman and every woman in this country.

This is not new, and that is the problem. Mr. Yoho was not alone. He was walking shoulder to shoulder with Representative Roger Williams, and that's when we start to see that this issue is not about one incident. It is cultural. It is a culture of lack of impunity, of accepting of violence and violent language against women, and an entire structure of power that supports that.

Mr. Yoho mentioned that he has a wife and two daughters. I am two years younger than Mr. Yoho's youngest daughter. I am someone's daughter too. [. . .] having a daughter does not make a man decent. Having a wife does not make a decent man. Treating people with dignity and respect makes a decent man, and when a decent man messes up as we all are bound to do, he tries his best and does apologize.

Lastly, what I want to express to Mr. Yoho is gratitude. I want to thank him for showing the world that you can be a powerful man and accost women. You can have daughters and accost women without remorse. You can be married and accost women. You can take photos and project an image to the world of being a family man and accost women without remorse and with a sense of impunity. It happens every day in this country. It happened here on the steps of our nation's Capitol. It happens when individuals who hold the highest office in this land admit, admit to hurting women and using this language against all of us. Once again, I thank my colleagues for joining us today.

This is not new

when a
man tries his best

to
show the world you can
accost women
without remorse

Re: Being Called a Mommy Writer

We have come a long way, but
there are still so many ways
women are identified and labeled
by their relationship to other
people. I say this as a "pastor's
wife." The married women who are
pastors on our staff do not find,
shockingly, that anyone calls their
husbands "pastor's husbands."

A few years ago, I started telling
our church that I don't like being
called a "pastor's wife." We are
making baby steps. My whole life
is some kind of experiment in
melding feminism and faith.

as a

wife

My whole life
is some kind of experiment in
melding feminism and faith

Re: Fat Girl Smiling in a Bathing Suit

Hi Kate. My name is ▮▮▮▮ and I was
wondering if I could ask you a series
of questions for my podcast, ▮▮▮▮▮▮.
Specifically I would love to know how
your husband feels about your poetry.
If he sees any of it and also about the
photos. If my wife was posting photos
of her body, I might want to know first!
This would be a candid convo, my
partner sometimes gives questions
ahead of time though if you prefer.
Thanks for the opportunity to chat.
I know you're busy! Here's to a great
end of the year!

my

husband
sees
my
body

and

gives

Thanks for the opportunity to
know Her

Re: Comment Section Under Fat Girl Smiling in a Bathing Suit

» Oh my goodness! Love the photo! I used to think
so many horrible things about my body . . . Now
I have a little gorgeous 2 year old daughter who
looks like a mini me and I think *that* is the most
perfect body on earth! Finally, after 33 years I've
learned to love me through her.

» Representation matters so much. As a girl who's
taken up space my entire life and always wished
I could be smaller, I get that now. Thank you for
modeling how to celebrate the you that exists,
just as you are.

» Thank you for sharing. I look very similar to you.
And you are beautiful. I never thought much of
my body, honestly. But last year, I started playing
roller derby at 33 years old. After birthing 3 kids,
surviving some serious health issues, fighting
depression, and having zero effs left to give. I
can say that I am the strongest I've ever been.
It's taught me to get back up again even after
crashing on cement. I learned to literally and
figuratively take up space. My body is amazing
and yours is too.

As a girl who
 wished

to exist

 I never thought of
my body But
 After birth

 I am strong
I get back up after
crashing I
 take up space. My body
and yours

Re: Check Out Your Exclusive Offer with ███ ███

> With ███ ███, you don't have to count, track or worry about what to eat. We give you everything you need to lose weight and feel great.

Ask about the Rapid Results Program and thank yourself later!

Choose from either:

Free 6 month program and $90 in Food Savings (purchase required)

Save 50% off ███ ███ Premium programs (stop anytime)

Offer Includes:

A weight loss expert whose job is to make sure you find and meet your goal.

A support group of like-minded individuals. Someone in your corner to cheer you on 24/7.

100+ ███ ███ foods so you can lose weight with food you love. No sacrifice. No naughty secrets.

Instant happiness with our scientifically proven program to help you lose weight 3x faster.

Note: there are no contract or cancellation penalties. All discounted items are yours at purchase. Find this and so much more on our social media channels at ███ and ███.

To a better life one day at a time,

███

"I have tried almost every program out there, but I've never found one as fast and easy as this. Thank you ███ ███! This WORKS."

you don't have to

lose

yourself

to find

Some

secret

happiness

there

is so much more

To life

Than This

Re: My Girlfriend from Another School

Even though I know you will probably just
make this into one of your "poems". . . can I
just say women lose weight all the time and
enjoy it? Their motivation is none of your
business? My gf loves to exercise and it's
great.

I will not be following, but I did scroll your
account when a co-worker reposted and I
cannot believe anyone finds this . . . good?
For example, may I be so bold as to bring
up form, theme, tone, any structure
whatsoever? I don't say this to discourage
you, but to help.

I will bring up one more point then leave
you alone. What is it about a healthy
lifestyle that makes you so uncomfortable?
Let women make the choice for themselves!
I'm sure you could benefit from hopping
on a treadmill or walking around what I'm
sure is some townhome development.

Even though you will
make
 women lose
 Their
 love

I will

 bring
 them
 to courage

I will bring

 them

 home

Re: Comment Section on Getting Your Body Back After Birth

» Ah, as I was getting stitches from my c section, brand new baby getting weighed, the doctor told me I was getting my summer body back. When I showed my utter confusion, after being pulled from the moment of my child's birth, she repeated it.

> » How can someone with close to a decade of training on the woman's body say something like that at a time like that?! No!

> » It's been a year and I'm still shocked.

» Holding my baby, not yet a day old, the morning after her birth in the hospital, the nurse told me about the supplements she sells and "oh don't worry, breastfeeding will take it right off."

 my brand
new baby getting weighed,
my body my confusion,
 my child's birth

 How can a
 woman's body

 the morning after
her birth

 take it

Re: Your Mommy Pouch

Hi Kate! I hope this finds you well.
I was hoping to chat with you today
about ██████ Tea, a new detox
cleanse that will literally change
your life. As a wife and mother, I
know it can be difficult to find time
for self-care with all the house-
cleaning and diaper changing, but
look no further! ██████ not only
helps you lose weight, but helps
you work towards a healthier
lifestyle. Shed the baby weight or
the Covid 15 in less than 4 weeks
by naturally detoxing your body
with this intentional and lucrative
blend or your money back. It's
never been easier to take control
and finally shed that mommy pouch.
I just know you are going to love it.

I hope this finds you

leaning

 towards a
life

 intent

 on

 love

Re: Relentless Motherhood

Hi Kate,

I got your lovely book of poems for Christmas and I've barely had a moment to read them. See, I just had my second baby boy on 10/29 . . . we live in New Orleans, and he was born right after a hurricane and days on end of the power being out. As you well know, life with two children is magical and chaotic. Most days I can laugh about the fact that dirty diapers are left on the kitchen table, that there is never a moment to think, that my clothes are constantly covered in bodily fluids . . . but today, I broke. It was actually my husband who broke first. Ironically in his haste and stress from the shitty morning of parenting, he broke a picture frame.

The glass shattered and he screamed and cursed and our 2 year old was confused while I held our 8 week old. Then he came into the room and cried. Then I cried. We're gonna be fine. It's just another morning in a thousand mornings . . . it will probably all be forgotten tomorrow, when there are new diapers to change and more ABC's to sing. But today it felt like to much. Enter your poems. I have stolen away to my room and when I read the line "nothing In this world can prepare you for this love's suffering. For joy and loneliness" I started to cry. I felt seen. You put words to my day, to my life as a mother. And it was so therapeutic to know I'm not alone in the agony and the ecstasy of it all, this blistering love for our babies and all that it entails. Thank you for your words.

*also to clarify, my husband accidentally broke the picture frame, because he was so frazzled. He's not a shit head.

Anyways, thank you.

I cried.　　　　　　　　It's just

another morning

　　　　　But　　　it felt like

　　　　agony and　　ecstasy　　this blistering love
and all that it entails

Re: Me Too

Thank you for your attention to the me too movement. I am a single mother and I am inspired by the women who have forged a path for shame-free truth. My husband is in prison for sexual assault against a coworker. I wish I could say I did not know her pain. I hope you share this as a beacon of hope for anyone still in an abusive relationship. I want to be the success story of a life lived after pain and without fear.

For thousands of years women like me didn't have a voice. We were not believed. I want a different world for my daughter. I want this to be an example of taking back a life. I want to fight for legislation that does not protect abusers. I want what we deserve—respect. Anyways, thank you, carry on.

women

want to
live
without fear

For thousands of years
We were not believed

this

is

what we

carry

Re: The Memory of Drunk Teenagers from Brett Kavanaugh to the Senate Judiciary Committee

Dr. Ford's allegation stems from a party that she alleges occurred during the summer of 1982, 36 years go. I was 17 years old, between my junior and senior years of high school at Georgetown Prep, a rigorous all-boys Catholic Jesuit High School in Rockville, Maryland. When my friends and I spent time together at parties on weekends, it was usually with friends from nearby Catholic all-girls high schools, Stone Ridge, Holy Child, Visitation, Immaculata, Holy Cross. Dr. Ford did not attend one of those schools. She attended an independent private school named Holton-Arms and she was a year behind me. She and I did not travel in the same social circles. It's possible we met at some point at some events, although I do not recall that. To repeat, all of the people identified by Dr. Ford as being present at the party have said they do not remember any such party ever happening.

17 year old

boys

and

girls

at the party do not
remember any such party ever happening

Re: Boys Will Be Boys by Donald J. Trump

I'm automatically attracted to beautiful [women]—I just start kissing them. It's like a magnet. Just a kiss. I don't even wait. When you're a star, they let you do it. You can do anything, Grab 'em by the pussy. You can do anything.

 women —
 don't wait
 You can do anything
 You can do anything

Re: Your Random Profile

Hello beautiful baby I am a sugar
daddy and I have many girls that I
pay their allowances and sort their
bills if you are interested. I will be
giving you $3,000 every day and
whenever you need it along with
sorting your bills and taking care of
your responsibilities. Like I said,
I have many girls but I know you
are one in a million. Let me take
care of you for a few days, months,
years. You will be satisfied. Are you
interested?

never

 in

 a
 million

years

Re: Freedom

Hello, my name is Victoria and I just
wanted to take a moment to reach out
to you . . . I just got your book "What Kind
of Woman," and I'm barely through the
entirety of it . . . but I'm crying so hard.
These poems are so beautiful and make
me feel so much better about myself. I
feel more empowered, or maybe I'm just
not holding myself so rigidly. Thank you
so much for sharing these words with
the world. So much love to you.

 I

 feel my
 power or maybe I'm just
not holding myself so rigidly
 in the
 world

Re: My Black Friend

Hi Kate. I hope this finds you well. It has certainly been an interesting year! :-) I wanted to reach out to you today to talk about something that's been on my heart. I've been searching for the right words, so forgive me if it's a bit jumbled. As a long time reader, I've enjoyed your writings about motherhood, but lately I've been disappointed in how you've vilified anyone who does not subscribe to the "black lives matter" movement. I am not a racist. I have African American friends. My husband is also not a racist. In fact he works with two African American men every single day. We choose not to see color and instead choose to see everyone by who they are on the inside. I know you try to use your voice to help others, but in doing that, is it necessary to also tear others down? You have an opportunity to bring women together . . . with your cleverly written poems and observations on motherhood. Not everyone who disagrees with you is a bad person. And by generalizing random groups as racist, you have erased a huge part of the equation: love.

I hope this finds you

 searching
 for

 every
 voice
 You have
 cleverly

 erased

Re: Your Facial Sagging

Hi Kate. My name is ███████ and I am a brand ambassador with ████████████! I've selected your profile for a special opportunity to experience our products in exchange for an honest review! ████████████ is an Anti-Aging program for anyone looking to show off their natural beauty while also reducing wrinkles, sun damage, facial sagging, and laugh lines. With combinations of dead sea minerals, collagen, vitamin C, and green coffee bean—we have put together a must have routine for every woman. Not only will you no longer cringe at yourself in selfie mode, our formulas have been proven to boost immunity, reduce fatigue, increase cellular resistance, and may even lower your risk of hypertension.

Growing older may be inevitable, but that doesn't mean we have to sit back and let it happen. Join us for a chance to look and feel your best with our base level starter set and we promise you'll see a difference in less than 10 days. **Plus, for every promotion you share with your followers, you will receive a $30 commission when they become a customer with us.**

We've never been more excited about a product and we hope you'll join us as we work to help anyone who has lived with low self-esteem due to aggressive aging.

Looking forward to chatting,

████████

how the

dead

 must
 cringe at our

 resistance

to look
 as
 if

We've
 lived

Re: The Male Ego

Recently I read your piece about being surprised men have been able to have power as long as they have and I find this to be a hilarious "take" as it is supremely BIOLOGY. Like what in the actual hell are you talking about? The reason men have been in leadership roles this long is because 1) it works 2) it was meant to be this way and 3) women WANT a male leader. It literally benefits them for men to be in a protector role. Think about every war and famine and natural disaster. Men fight/do/make change on BEHALF of the women. It's honest to god the basic human playbook.

read

a

book

Re: Men Sending Unsolicited Dick Pics, Praying the Gay Away

As someone actually named
Greg, I can promise I'd never
ask for your number lol. You're
not exactly my "type." Even if
you had the body, I think there
are a few wires crossed! One,
saying you'll pray for someones
sin is not asking them to die.
God (capital G) made men to
be with women (1 Timothy 1:10).
Anyways I WILL pray for you and
that you're heart will be changed
to submit to the LORD'S will for
he will never abandon you.
Unlike all your readers who
cheer on your heresy but will
unfollow even after one slip.
All of this to say, real Gregs do
exist and he is praying for you!

I promise

 my
 body

 I

 will
never abandon

 her
 even after
All this

Re: The Universal Greg

Just preordered your book and then I saw
the Vogue article and just . . . wow, you're
incredible. I have Moon Song set as my
phone background right now. I really want
to thank you for doing this work. You are a
tremendous inspiration. I quit my toxic
consulting job last week because I read
your Greg poems and decided enough was
enough.

I'm now at a firm with wonderful, supportive
women. Please don't feel obligated to reply
as I know you have a life to live and
Instagram can be overwhelming; I just felt
compelled to thank you for your
emotional labor and for your words. And
wanted to say that for every Greg, there
are one hundred women ready to throat punch
Greg for you.

 I saw
 the
 Moon as my

 inspiration. I

 decided

 women
 have a life to live
 I

 want that

 for you

Re: Smart Women by Joseph Epstein
for the *Wall Street Journal*

Madame First Lady—Mrs. Biden—Jill—kiddo: a bit of advice on
what may seem like a small but I think is a not unimportant matter.
Any chance you might drop the "Dr." before your name? "Dr. Jill
Biden" sounds and feels fraudulent, not to say a touch comic.
Your degree is, I believe, an Ed.D., a doctor of education, earned
at the University of Delaware through a dissertation with the
unpromising title "Student Retention at the Community College
Level: Meeting Students' Needs." A wise man once said that no
one should call himself "Dr." unless he has delivered a child. Think
about it, Dr. Jill, and forthwith drop the doc.

a touch comic

the dissertation with the

unpromising

man

Re: Your Excellence by Debi Pearl

You can only realize your womanhood
when you are functioning according to your
created nature. To covet his role of
leadership is to covet something that will
not make God, you, or him happy. It is not
a question of whether or not you can do a
better job than he; it is a matter of doing
what you were "designed" to do. If you
successfully do the job of leading the
family, you will not find satisfaction in it. It
is far better that the job be done poorly by
your husband than to be done well by you.
Your excellence as a help meet to him may
very well be God's plan for improving his
leadership role in the family. Your female
nature cannot be retrofitted to the male role
without permanent damage to the original
design.

You

 were designed to

 find satisfaction in

your
 excellence

 Your
nature cannot be retrofitted to the male
without permanent damage to the original
design

Re: Comment Section Under a Gay Couple's Surprise Engagement

» In the beginning God created mail and female . . . and that will always be the way as God's plan

» Disgusted that WGAL would make this a news story.

» I am not going to judge but all I do know is that at the end every knee shall bow and every tongue confess.

» People can make themselves believe anything to suit themselves.

» We tend to be lovers of ourselves rather than lovers of Christ and are in love with our own ideas and not the way God set the example because in the beginning it was not men loving men and women marrying women

» We have adjusted our world to ourselves and not God. Try to explain away Sodom and Gemmorah!

» Another example of FAKE NEWS from another liberal news outlet. Stop trying to indoctrinate us with this crap and stick to actual news.

» I will not judge, however the lord above will. I pray you find a way to live in the world but not of it.

» Invite Jesus inside your heart and you will be saved. God is just but his mercy endures forever through his son Jesus Christ.

» This is sick. Praying God changes your heart accordingly.

God created

love

to

explain

the
world

inside us

Re: Sodom and Gomorrah
from Isaiah 1:9, 15–17

Unless the Lord Almighty
had left us some survivors,
we would have become like Sodom,
we would have been like Gomorrah.

When you spread out your hands in prayer,
I hide my eyes from you;
even when you offer many prayers,
I am not listening.

Your hands are full of blood!

Wash and make yourselves clean.
Take your evil deeds out of my sight;
stop doing wrong.

Learn to do right; seek justice.
Defend the oppressed.
Take up the cause of the fatherless;
plead the case of the widow.

When you spread out your hands in prayer,

 listen

 to

 the oppressed
 the fatherless
 the widow

Re: An Hour of Your Time

Hi! My name is ███████ ████████,
a freelance book reviewer, and I'd
love to pick your brain about
being a mommy writer. Is this the
best way to reach you? My
questions are on content. I find
your work well written, but the
subject matter not necessarily
what I want to read about. Not
unbearable, but also not
universal. I'm wondering if
studying some of the classic
writers (Poe, Hardy, Thoreau)
would help hone in your work to
be more relatable. Also the way
we have allowed poetry in any
space concerns me. How can we
determine what is good from
otherwise? I'd love to take at
least an hour on the interview, so
let me know what works best for
you. Afterwards we can shape
the piece to include excerpts of
your work and perhaps explain
what kind of women you are! ;)

it is

unbearable

 the way
we have allowed

 what is good
 to take
 the

 shape
 of

 men

Re: Separation of Worth and Body

Thank you so much for your work
on acceptance and body neutrality.
To love yourself is easier said than
done. I've been struggling with EDs
for most of my life. Therapy in the
90s consisted mostly of being told
to love ourselves without being
given the tools to interact with an
ever body focused world. Today
there are so many more resources
and therapies that focus on finding
the root of our thought patterns.
You can't replace therapy with
Instagram infographics, but I so
appreciate the encouragement
to create safe feeds and timelines.
I also love the challenge to live
without fear and invitation to fail
and start over again tomorrow.
It is refreshing and I am here
for it.

To love yourself

 is
to love
 the
 world

and find

 a place

to
 live

 in
 it

Re: Teaching Students the Art of Connection

Hi! I am a middle school teacher and I just wanted to let you know that I used your art to introduce them to poetry. My educational experience with poetry was always negative because I felt like everyone else "got it" and I could never see what they were talking about. In my adult life I cling to poetry. I want to show my students that poetry is so much more than finding the hidden symbolism and the test answers and instead about connection and expression. Thank you so much for being you and creating art that inspires people in so many ways.

I
wanted
art

poetry was

hidden
in

so much
in so many ways

Re: Comment Section Under a Photo of a Tired Mother in Pandemic Times

» This looks like a photo people will look back on one day in "the 2020 pandemic" archives, like we look back at pictures of mothers during the Great Depression.

» YES SISTER I FEEL YOU

» Gosh, this. My son's (small) preschool daycare reopens next week, and we're anguishing over whether we send him. Whether it's safe. Solidarity to all caregivers, in the many shapes that caregiving takes, who are grappling with worry and stress, fear and love right now.

» [This is] History.

» Mothers are heroes <3 <3 <3

 people will look back
one day
 at mothers

 My small
 anguish

 the shape
 caregiving takes with
 fear and

 History

Re: Storming the Capitol

You are just another dumb liberal ████████.
Pelosi and Congress are insisting on
certifying electoral college votes from states
that had illegal activity in those states by
state officials who cannot change a law that
violated the rights of all of the states citizens
per the U.S. Constitution. Everyone should
be protesting! It's pulling your weight at this
point. They are taking YOUR rights away
from YOU! You get off on people standing
for something they believe except when it
doesn't line up with your "values." They
didn't burn the place down in revenge.
Nancy Pelosi should be grateful they didn't
catch her butter face in her office. Bet it
smells like stale perfume, booze and
rotting fish. Good luck on your fake
goodwill and swallowing in the morning
after spewing so much bullshit. Your
blowhole is even bigger than your ass.

You

 insist on

 the

 pull

 of

 revenge

 but it

 will swallow

 You

whole

Re: Leaving the White House from Donald J. Trump to Mike Pence

"You can either go down in history as a patriot,"
Mr. Trump told him, according to two people
briefed on the conversation, "or you can go
down in history as a pussy."

you can go

Re: Personal Branding

You would sell so many more books
if you didn't spend so much time
posting your ugly leftist agenda. The
funny part is black people don't care
about you. Gay people don't care
about you. "Transgender" people
don't care about you. You are just
a fat, dumb girl from Pennsylvania
to them. When will you realize they
don't owe you a thing? You've
abandoned half your reach for
nothing other than scoring some
brownie points with socialist
interweb losers. Your greatest
and most powerful resource here
is literally just butting the hell out.
People want stability right now.
Think of your readers as customers.
Sincerely, a lover of common sense.

When
we
abandon each
other

we lose our greatest
power
the
ability
to

love

Re: Monika Diamond

Thank you so much for calling attention to the horrific abuse against LGBTQ folx. I appreciate your support as I recently came out to my family and friends as gay and non-gender conforming and defending not only my own dignity and worth, but an entire group of people is not easy. Up until this summer, I had never breathed a word about who I was to anyone. Then, a few days before I turned forty, I realized I would not make it much longer in this world if I continued to be untrue to myself. I debated telling my parents in a letter or in person. I knew they wouldn't be exactly joyous or anything (they are in their 70s) but still I hoped for some sense of belonging. What I received was confusion and ultimately intolerance. It was the evening of my birthday party. We were in the driveway, socially distanced. My dad had always said you should be true to yourself, that night he said I was just drunk and confused. I haven't had a drink in 17 years. I felt so alone. The only thing that has saved me is support and kindness from strangers. Don't stop speaking up and out. It means more than you know.

your

 dignity
 is not Up

 for

 debate
 you

belong

 to yourself
 alone

Re: Holding Police Accountable

I wish you would stick to poetry
instead of constantly being
political, just one reader
preference

Have you ever thought what
would happen if the police
disappeared?

Is what you say going to change
anything? (No)

When you stay in your lane,
better connection happens

I know staying silent isn't cool
but just a thought

I wish you would

disappear

Is what you say

When you stay

 silent

Re: Poems Made from Online Messages

Hi. My name is ███████. I was wondering if I could ask you a few questions about your poetry. First, don't you think these blackouts just encourage trolls to message you? You obviously love it, so don't you think you're kind of asking for them at this point? I met a writer last year who swore off social media and I believe she's better for it. :) Maybe instead of getting even you could just delete or go offline. And I hope your kids aren't reading this stuff. I meet kids all the time who will be unearthing all sorts of trauma in therapy or elsewhere because of their parents online shenanigans. I know it bruises the ego to hear this and I know you'll also say this is your platform and I have no place here. But when you look back in the internet history books, what legacy do you want to leave? A professional writer or someone [who] makes hateful things out of reader feedback?

I could ask you

to
 love

 me

 instead

 I hope
you
 meet the
 earth
 where

she bruises
 and know
 your
 place
 in
the history

 of
 things

Re: My Daughter's Struggles

Hi! I found your profile recently when a friend posted one of your poems to her stories. I just loved the way that you're able to repurpose words from nasty messages you get from strangers. I don't police my teenage daughter's social media, but I know she gets messages similar to the ugly ones you receive—apparently all women do. I'm horrified at what harassment women must simply accept as the "price to pay" for existing online. That you're able to turn these ugly and hateful messages into something different, something uplifting, just really touches some unknowable thing inside me. It gives me hope. I'll never deal with my daughter's online struggles, I'll never know what she knows. But by sharing your page with her, I can hope she's able to see whatever horrible words come to her DMs as what they are— words. Words she can define herself, rearrange and repurpose to take away their intent to harm. Thank you so much for giving this dad some much needed hope in these hopeless times!

my daughter's

"price to pay"

 touches some
unknowable thing inside me

 I'll never
know what she knows. But
 I can hope she's
able to see

 herself

 and repurpose
 harm

 in hopeless times

Notes on Sources

Re: Why Americans Respect Conservative Women from Steve Bannon to the *New York Times*

Source: 2011 radio interview reported on by the *New York Times*.

www.nytimes.com/2016/11/15/us/politics/stephen-bannon-breitbart
-words.html

Re: That f**** b**** from Rep. Alexandria Ocasio-Cortez to the House of Representatives**

Source: Rep. Alexandria Ocasio-Cortez's House Floor Speech on July 23, 2020.

www.rev.com/blog/transcripts/rep-alexandria-ocasio-cortez-floor
-speech-about-yoho-remarks-july-23

Re: Being Called A Mommy Writer

Source: Carrie Stephens, @wordsbycarriestephens

Re: Comment Section Under Fat Girl Smiling in a Bathing Suit

Sources: Elis Hackmann Pereira, @elishpereira; Nicole Beardsley, @nicolebeardsley1; Katy Luxem, @katyluxem

Re: Comment Section on Getting Your Body Back After Birth

Sources: Caroline Bean; Bethany Nissley; Sandra Calm

Re: Relentless Motherhood

Source: Crystal Clem, @crystalclem

Re: Me Too

"Anna," writer of this message, would like to point anyone experiencing domestic violence to the National Domestic Violence Hotline at 1-800-799-SAFE and https://www.thehotline.org/.

Re: The Memory of Drunk Teenagers from Brett Kavanaugh to the Senate Judiciary Committee

Source: Brett Kavanaugh's opening statement on September 27, 2018.

www.nytimes.com/2018/09/26/us/politics/read-brett-kavanaughs -complete-opening-statement.html

Re: Boys Will Be Boys by Donald J. Trump

Source: A 2005 recording obtained by the *Washington Post*, also reported with a full transcript by the *New York Times*.

www.nytimes.com/2016/10/08/us/donald-trump-tape-transcript.html

Re: Freedom

Source: Vikki Voutour

Re: Men Sending Unsolicited Dick Pics, Praying the Gay Away

This message was sent in response to the poem "Reasons to Log Off" by Kate Baer.

Re: The Universal Greg

Source: Annika Inkeri

Re: Smart Women by Joseph Epstein for the Wall Street Journal

Source: From Joseph Epstein's piece "Is There a Doctor in the White House? Not If You Need an M.D.," published by the *Wall Street Journal* under the editorial control of Matt Murray.

www.wsj.com/articles/is-there-a-doctor-in-the-white-house-not-if-you -need-an-m-d-11607727380

Re: Your Excellence by Debi Pearl

Source: *Created To Be His Help Meet* by Debi Pearl

Re: Comment Section Under a Gay Couple's Surprise Engagement

Registered Nurse Eric Vander Lee, twenty-six, and his boyfriend Robbie Vargas-Cortes, thirty-one, were engaged on December 23, 2020, at a South Dakota hospital when Robbie, a paramedic, was getting his vaccine. When Robbie came in for his scheduled vaccination appointment to be administered by Eric, he had a surprise up his sleeve—literally. When Robbie rolled up his shirtsleeve so Eric could give him the vaccine, Eric was shocked to find an engagement ring taped to his boyfriend's arm.

www.nbcnews.com/feature/nbc-out/nurse-giving-covid-vaccines -surprised-proposal-viral-video-n1253062

Re: Sodom and Gomorrah from Isaiah 1:9, 15–17

Source: From the book of Isaiah, as translated in the New International Version (NIV), an English translation of the Bible first published in 1978 by Biblica (formerly the International Bible Society).

Note the Bible never teaches that same-sex behavior was part of Sodom's sin. The term "sodomy" was not coined until the eleventh

century, and even then it was widely used to refer to all nonprocreative sexual acts (including heterosexual acts), not same-sex relations specifically. Isaiah 1 equates the sin of Sodom with oppressing marginalized groups, murder, and theft.

Re: Separation of Worth and Body

Source: Amelia Stevens

To find immediate support for an eating disorder, call, chat, or text the National Eating Disorders Association at www.nationaleatingdisorders .org.

Re: Teaching Students the Art of Connection

Source: Taylor Lee Rowell (@tay_rowell)

Re: Comment Section Under a Photo of a Tired Mother in Pandemic Times

Sources: Megan Hendrick (@megan_rhodes); Lisa Wenger (@lisafianna); Mari Huertas (@marihuertas); Cassey Bloomfield (@casseybloom); Grace 은진 Han (@graceiiny)

Re: Storming the Capitol

On January 6, 2021, the United States Capitol was stormed during a riot and violent attack against the US Congress. A mob of supporters of President Donald Trump attempted to overturn his defeat in the 2020 presidential election by disrupting the joint session of Congress assembled to count electoral votes to formalize Joe Biden's victory. The Capitol complex was locked down and lawmakers and staff were evacuated while rioters occupied and vandalized the building for several

hours. More than 140 people were injured in the storming. Five people died either shortly before, during, or after the event.

https://en.wikipedia.org/wiki/2021_storming_of_the_United_States_Capitol

Re: On Leaving the White House from Donald J. Trump to Mike Pence

Source: The *New York Times* reported in January of 2021 that Trump relentlessly pressured Pence to overturn the election results, noting this last-ditch effort overheard by multiple sources.

www.nytimes.com/2021/01/12/us/politics/mike-pence-trump.html

Re: Monika Diamond

On March 18, 2020, Monika Diamond, a thirty-four-year-old transgender activist and business operator, was murdered in Charlotte, North Carolina.

For more information on how to support the Black transgender community, visit the National Black Trans Advocacy Coalition, the only social justice organization led by Black trans people, to collectively address the inequities faced in the Black transgender human experience.

https://blacktrans.org/

Re: Holding Police Accountable

This piece originally appeared in *What Kind of Woman* under the title "Comment Section." The original message was sent in response to a call for police reform after the horrific murder of George Floyd on May 25, 2020.

Acknowledgments

Thank you to my agent, Joanna MacKenzie, for talking me off
a ledge and into this book. To my editor, Mary Gaule, for her
enduring support and incredible work getting this right.
To Suzanne Mitchell and Beth Hicks for their help with the
audiobook. To Joanne O'Neill for the cover design as well as the
rest of the wonderful team at Harper Perennial, including
Kristin Cipolla, Megan Looney, Amanda Hong, Jen Overstreet,
Amy Baker, and Lisa Erickson.

To my very first reader, Maureen Nolt, who dropped everything
to read the first draft in a moment of pure panic. And to my
mother and Kayla Shuman who cared for my children during a
pandemic so I could write this book.

Most important, thank you to those who regularly lift up authors
and artists online and in real life with words of affirmation and
love. I am so grateful to receive your thoughtful messages
and honored when you share your stories with me. I would
especially like to thank those who allowed me to include their
positive messages in these pages both anonymous and named. A
tremendous gift.

This book is dedicated to my daughter, Eva, who was born on a
cold December night eight years ago, ready and eager to face this
world and all that it entails.

About the Author

Kate Baer is an author and poet based on the East Coast. Her first book, *What Kind of Woman*, was a #1 *New York Times* instant bestseller and featured in publications such as *Harper's Bazaar*, vogue.com, and the *Chicago Review*. Her work has also been published in *The New Yorker*, *Literary Hub*, and the *New York Times*.

ALSO BY KATE BAER

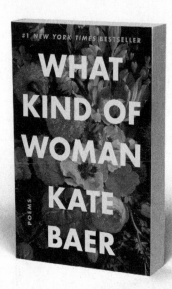

A stunning and honest debut poetry collection about the beauty
and hardships of being a woman in the world today, and
the many roles we play—mother, partner, and friend.

**"If you want your breath to catch and
your heart to stop, turn to Kate Baer."**

—JOANNA GODDARD, *Cup of Jo*
